P9-DBT-158

700 KIDS ON GRANDPA'S FARM

by Ann Morris

photographs by Ken Heyman

Dutton Children's Books New York

CIP Data is available.

Published in the United States 1994 by
Dutton Children's Books,
a division of Penguin Books USA Inc.
375 Hudson Street, New York, New York 10014

Designed by Riki Levinson

Printed in Hong Kong First edition
10 9 8 7 6 5 4 3 2 1
ISBN 0-525-45162-5

This book is dedicated to kids
everywhere in the world.

With grateful acknowledgment to
all the staff at Coach Farm
and especially Miles and Lillian Cahn,
who have made it all possible.
Also to the goats who live and play there
and have provided so much pleasure and
delicious cheese for so many children
and their families.

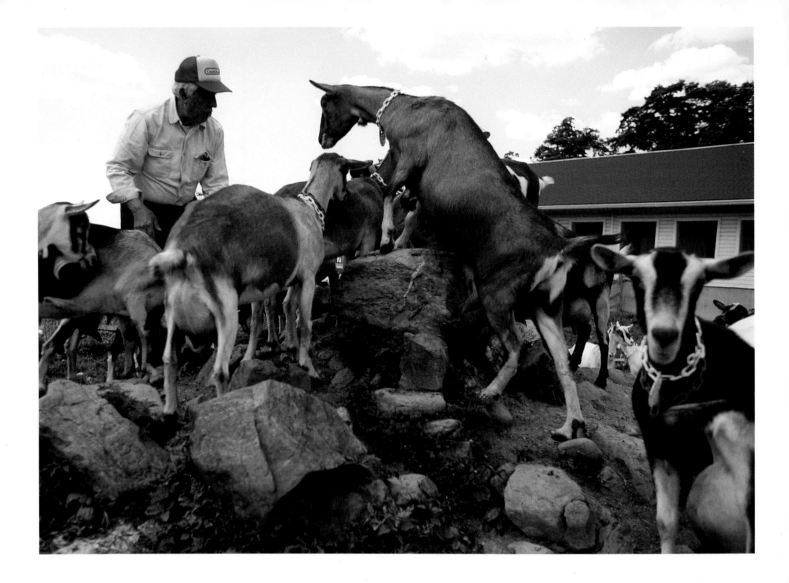

Miles Cahn is a busy man. He and his wife, Lillian, own a dairy farm. There are seven hundred goats who live on their farm.

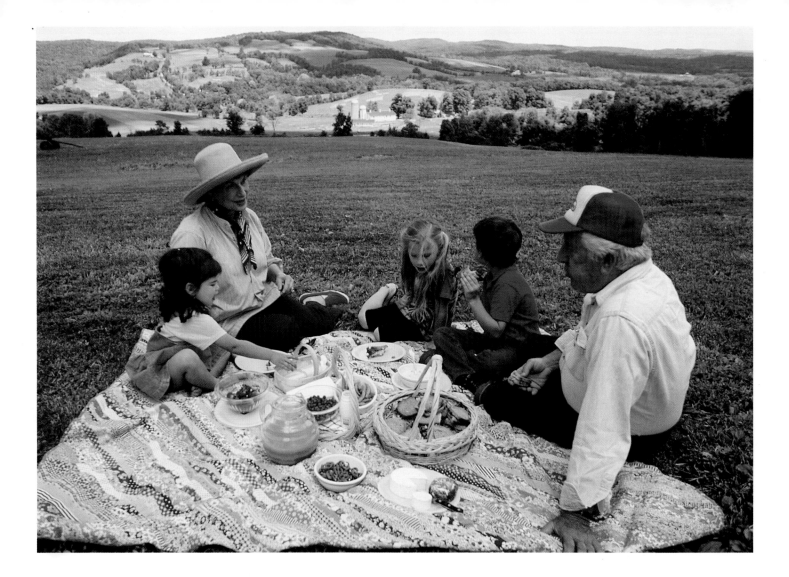

They make goat cheese from the goats' milk. They also make yogurt. Their farm looks toward the rolling hills of the Hudson River Valley, where they like to picnic with Annie, Liza, and Jake, their grandchildren.

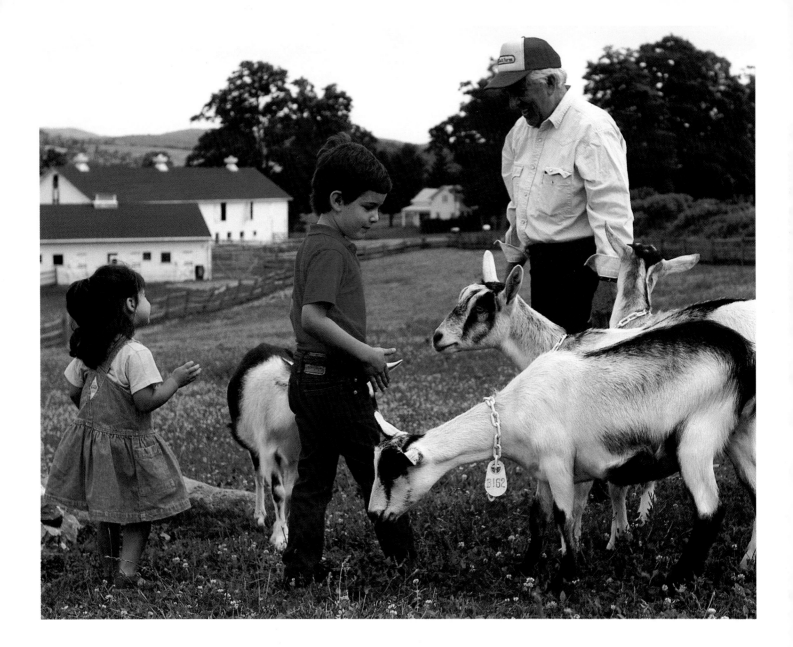

The children love to visit. They come to the farm
frequently and play with the goats.

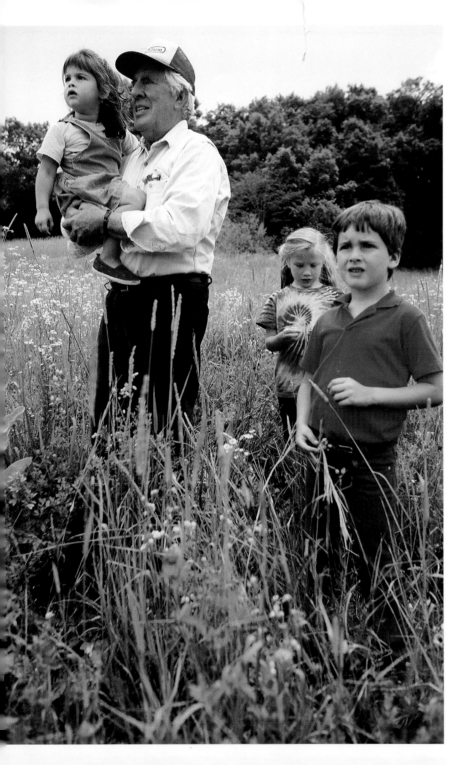

They get up early to watch the sun come up over the mountains.

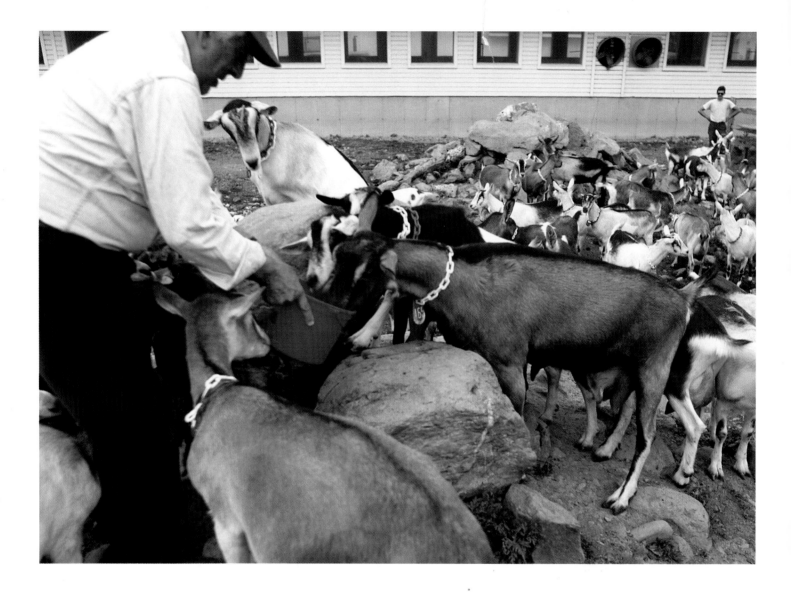

Grandpa gives the goats a special treat—a mixture of corn, oats, barley, and soybeans.

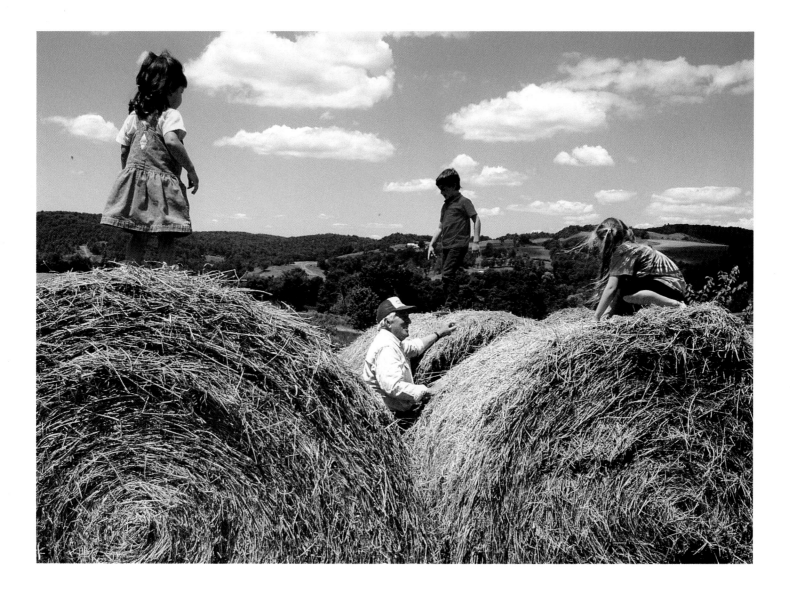

He takes the children out to the hay fields. This hay is fed to the goats that produce the milk that is made into the cheese on the farm.

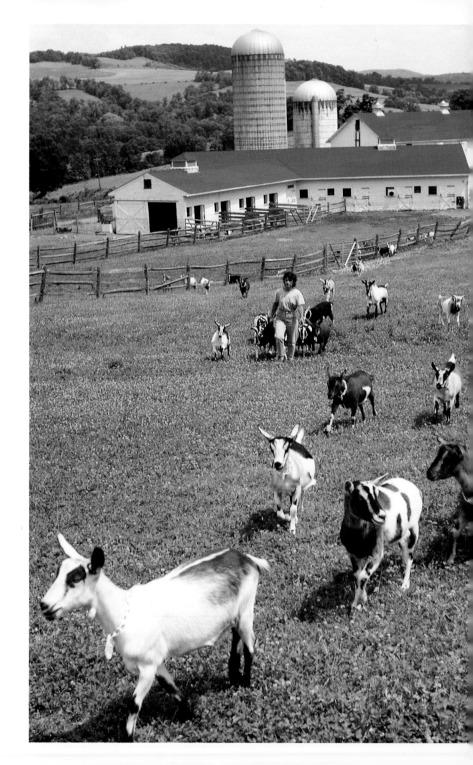

Goats need a lot of exercise. Grandpa Miles's daughter, Susi, takes them for a run.

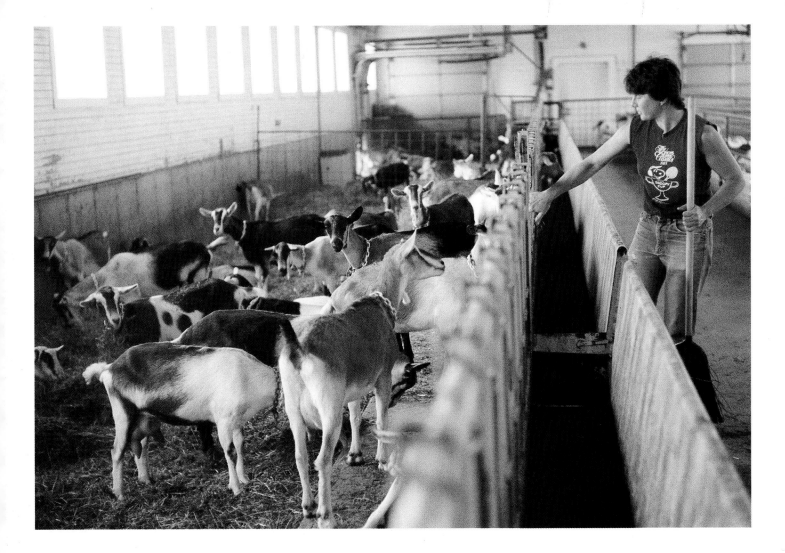

The goats live in a barn, where they can rest out of the sunlight. It is called a loafing barn because they stand around in it all day. They sleep here at night.

The barn must be kept very clean so that the goats stay healthy.

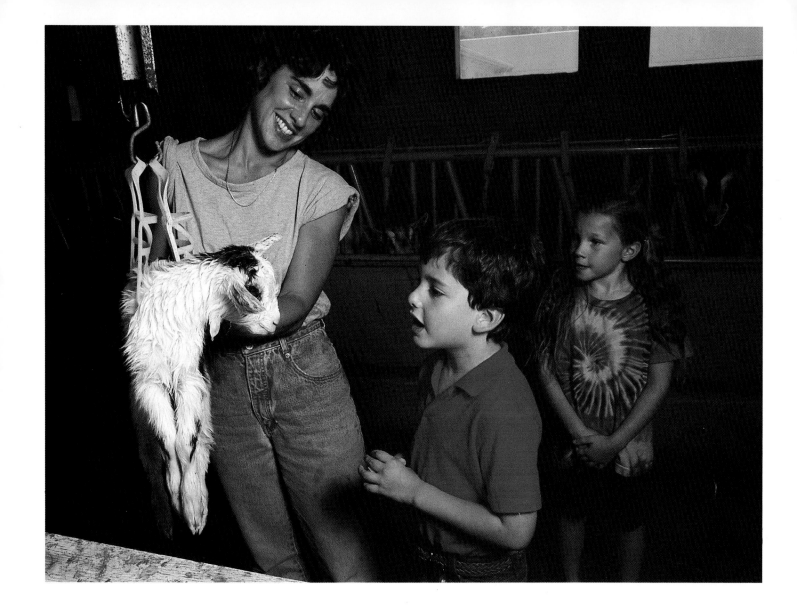

Baby goats are called kids. When a kid is born, it is
weighed. Then it is given a name. This one is called
Nibbles.

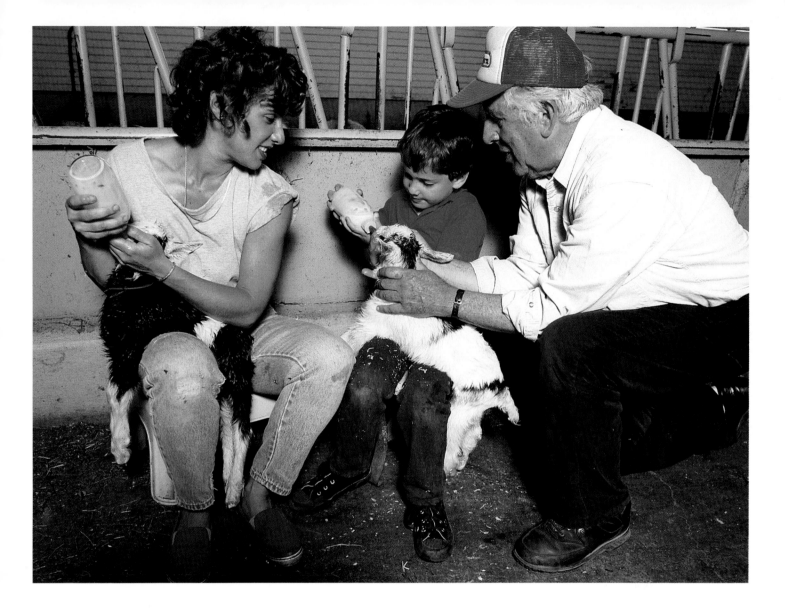

Sometimes Grandpa and Susi have to feed the kids with a bottle. Grandpa teaches Jake how to do it.

Annie makes a friend by feeding one of the kids.

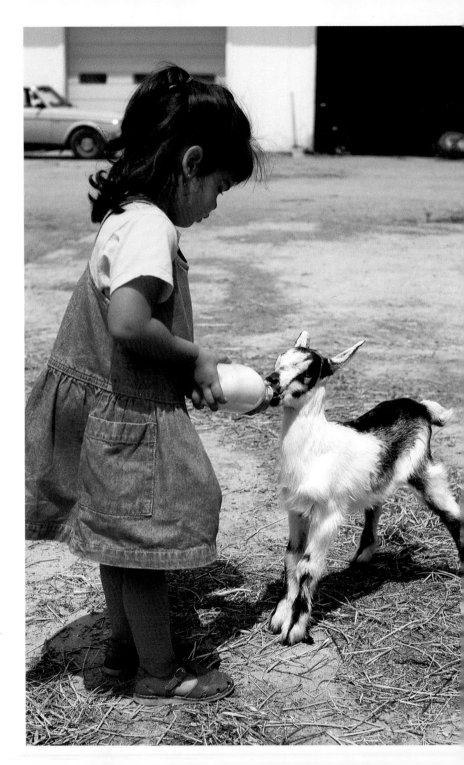

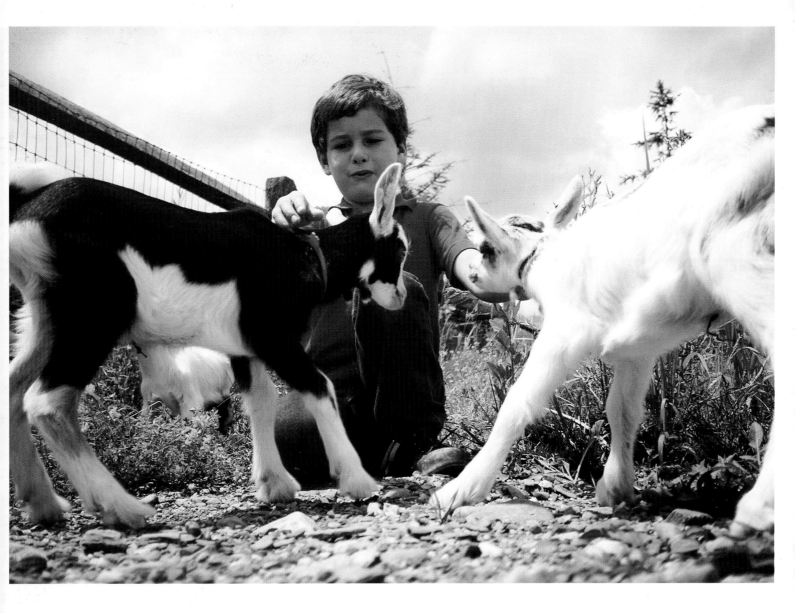

While the children play with the frisky kids, the workers on the farm are busy. Taking care of the goats is one part of the work. Making cheese is another.

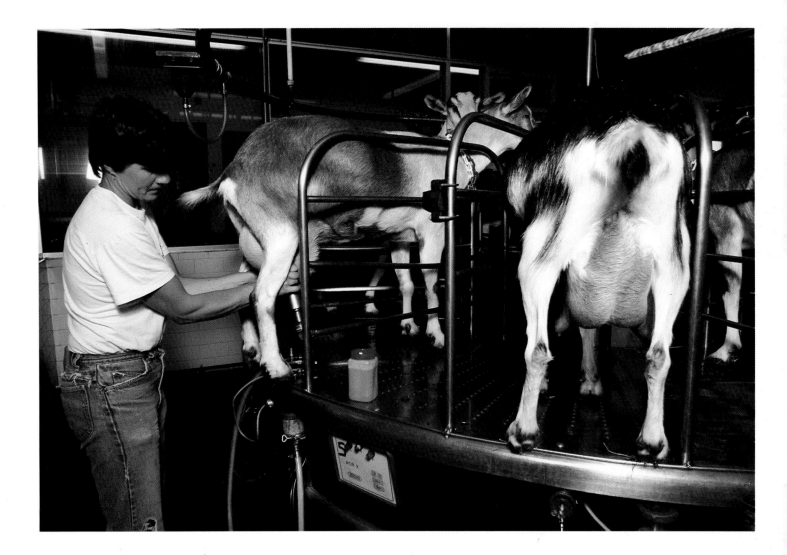

The older goats are milked twice a day. Each goat gives about five pounds of milk every day. Milking is done on a machine called a carousel. The goats hop on it to be milked.

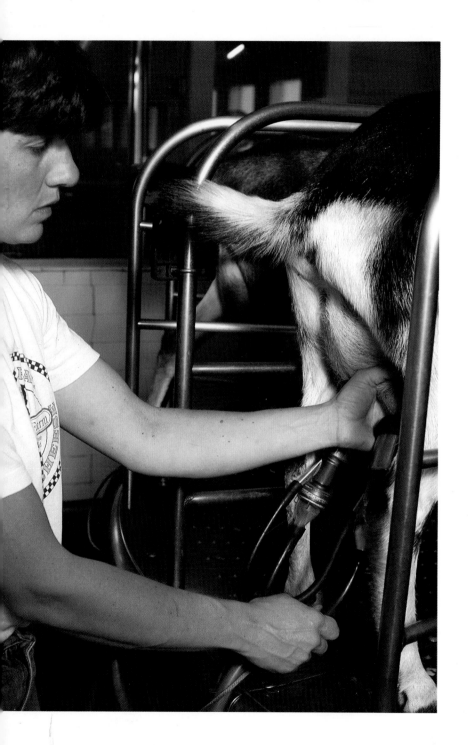

As the carousel turns, the milker attaches a pump to one goat after another. The milk goes from here directly into the creamery. There it is made into cheese and yogurt.

In the creamery, it is poured into a big steel tub called a pasteurizer. This heats the milk and kills the germs.

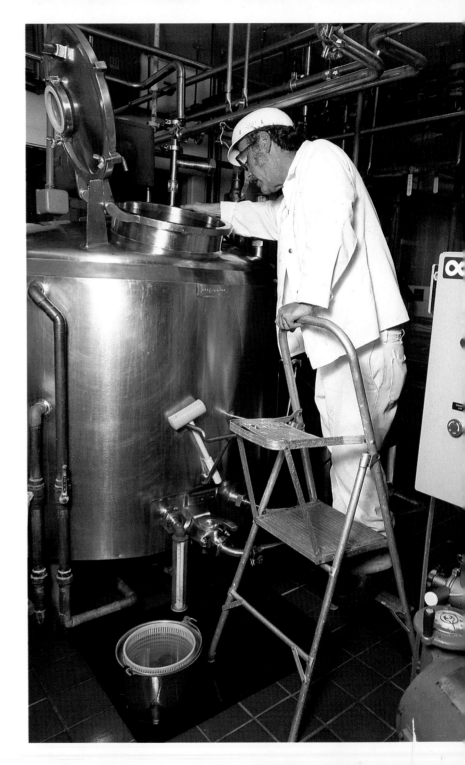

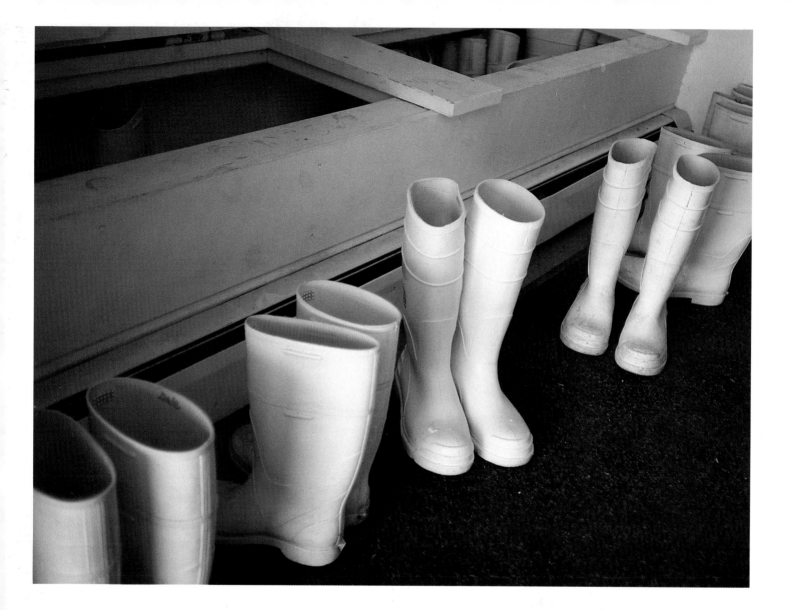

Everyone who works in the creamery must wear a white coat or apron and white boots. Things have to be kept spotlessly clean.

When the milk is cool,
it is poured into tubs.
Then a culture is added.
By the next morning,
the milk has changed. It
is thick and more like
cheese. The thick part is
called the curds, and the
watery part is called the
whey—just like in "Little
Miss Muffet."

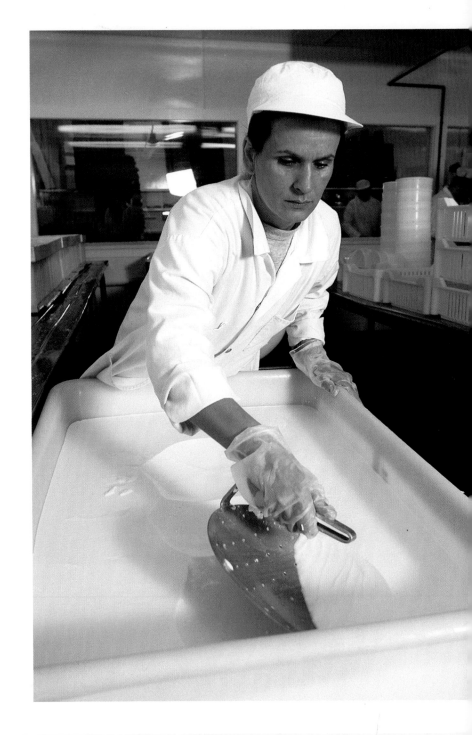

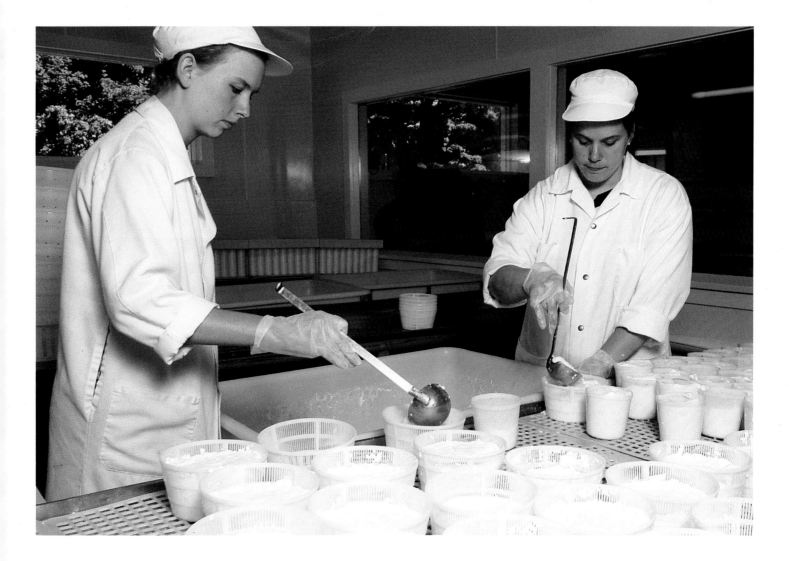

The cheese makers scoop up the curds with ladles. They put them into molds that have draining holes in them. The whey drains out through these holes. The thick curds begin to look and taste like cheese.

When most of the whey has dripped through the holes, the cheese is tapped out of the molds.

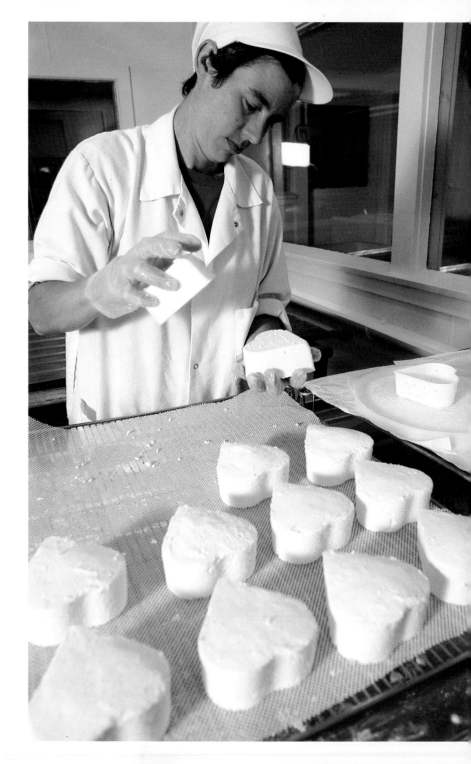

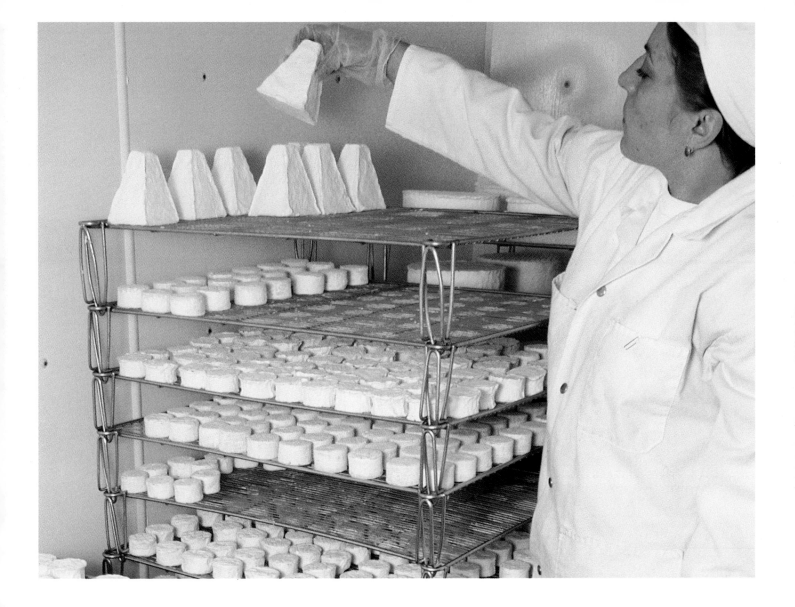

The cheeses are many different shapes. Sometimes herbs are sprinkled on the cheese to give a special taste. The cheeses are stored for a while in a refrigerator.

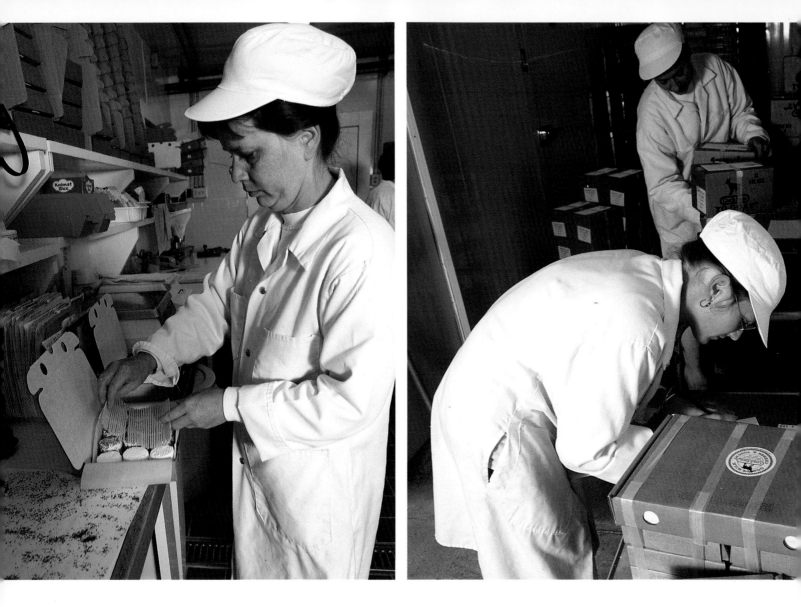

Then they are wrapped and put into boxes. The boxes are addressed.

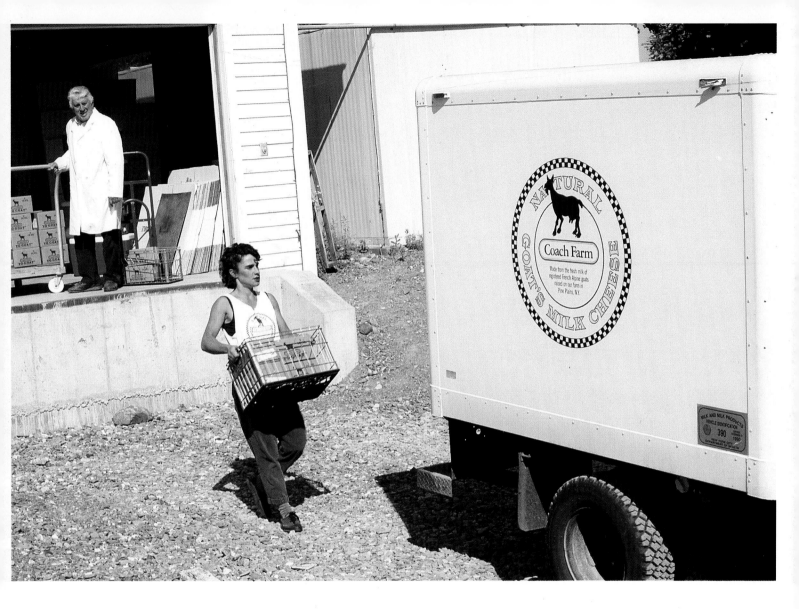

The trucks are loaded. Some of the cheese is delivered to stores. Some cheese is taken to a farmers' market, to be sold there.

Market day is a busy day for everyone. Grandpa Miles stays back at the farm. He has many jobs to do in his cheese business. He plans all the work on Coach Farm—going over orders, checking reports, and arranging shipping.

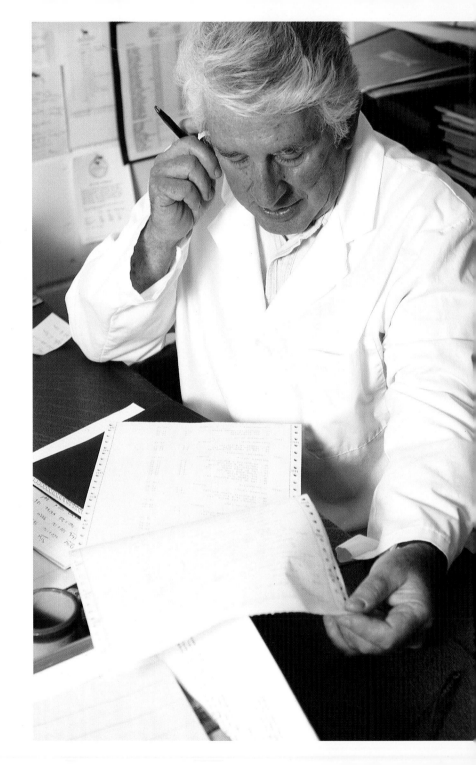

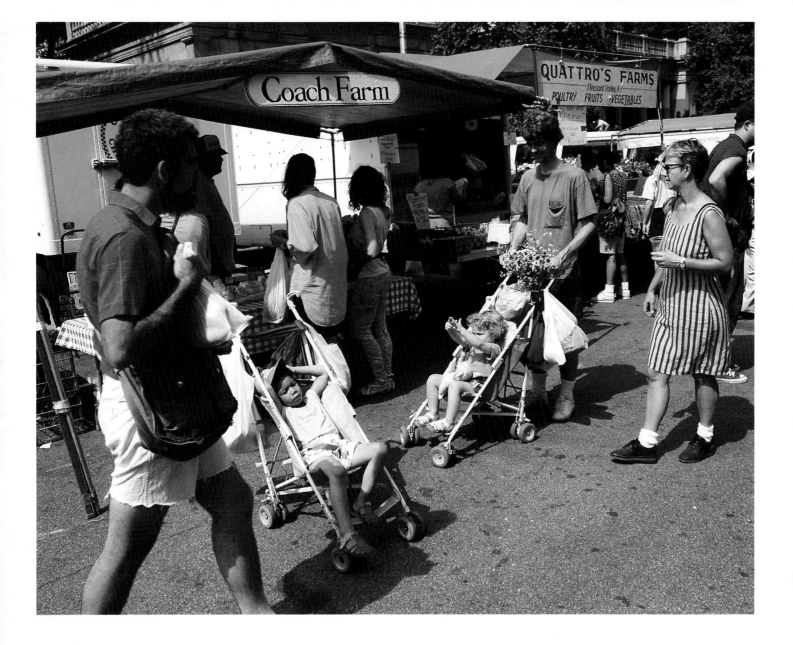

In the city, the farmers' market is bustling. The Coach Farm stand is set up.

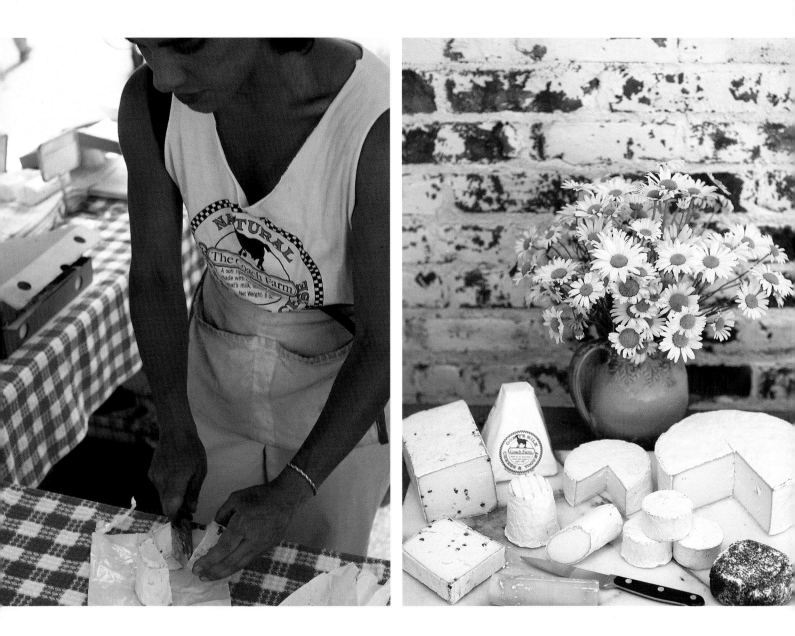

Susi cuts up pieces of cheese and arranges them so her customers can decide what they want.

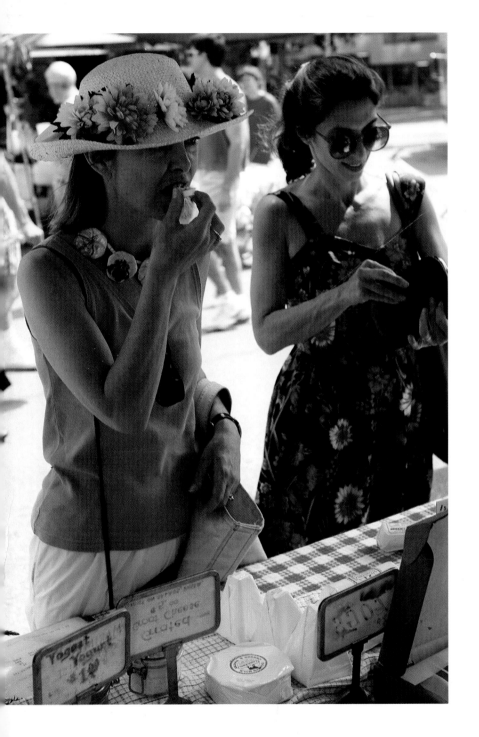

The goat cheese is delicious. The customers buy several kinds.

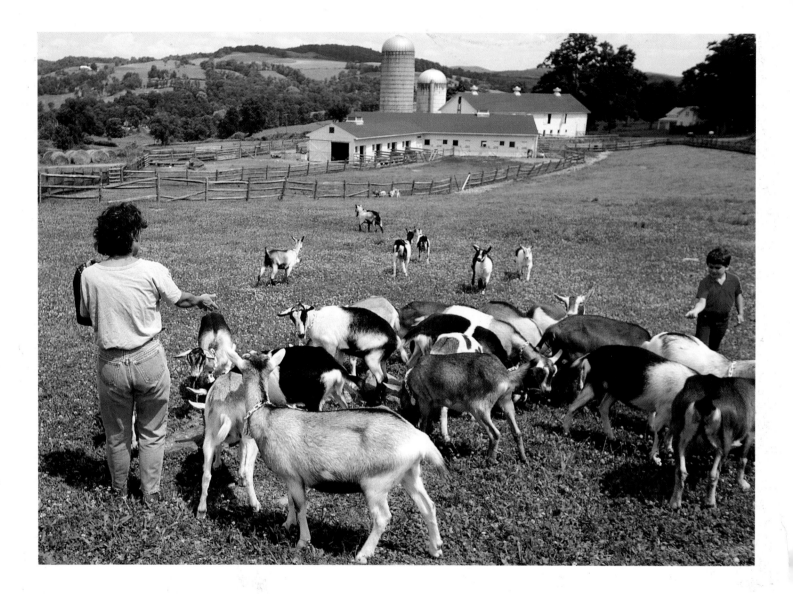

Susi is happy to be back at the farm. The people at Coach Farm think the goats who provide the cheese are wonderful. They like working on Grandpa's farm.

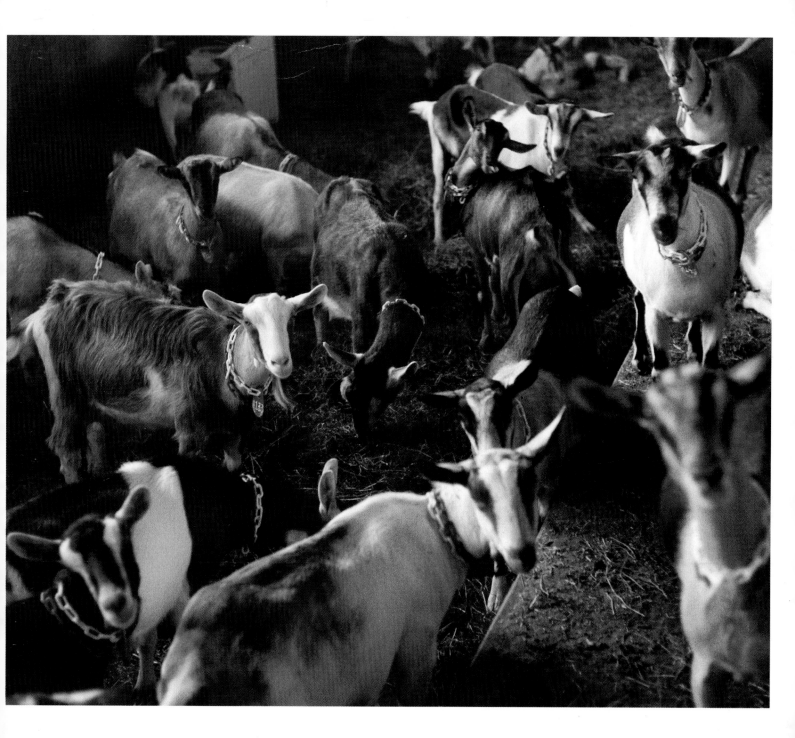

Goat Farm Words

Carousel A kind of milking machine that looks like a merry-go-round for goats.

Creamery A place where milk products, including cheese and yogurt, are made.

Culture Bacteria that is added to milk in the process of making yogurt and cheese.

Curds The thick part of the milk, separated from the whey in making cheese.

Herb A plant used to add flavoring to cheese and in cooking.

Kid A baby goat.

Ladle A kind of long-handled scoop used to spoon up curds.

Loafing barn A place where the goats rest all day.

Mold A container for the curds that gives the cheese its final shape.

Pasteurizer A machine that destroys harmful germs by heating the milk.

Whey The watery part of the milk, separated out in cheese making.

Yogurt A not-quite-solid product made from milk and a kind of bacteria.